INSTRUCTOART

LESSON 1

INFORMATIVE YET AESTHETICALLY PLEASING
PRESENTED BY MATTHEW VESCOVO — MASTER OF THE OBVIOUS

TABLE OF CONTENTS

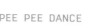
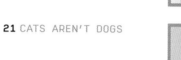

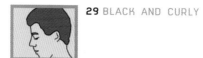

People often ask what inspired me to create Instructoart. The truth is, the inspirational seeds for Instructoart were planted some twenty-five years ago, when I was a very young boy.

It happened on a camping trip with my family. It was late at night and everyone else had gone to sleep, but I stayed up staring at the campfire. I sat there for hours, captivated by the beautiful flames as they rose up into the night sky. With each passing moment, the orange and yellow glow drew me in further. Mesmerized, I inched closer and closer toward the flames. Eventually, in an almost trance like state, I stuck my entire head into the fire.

It was a tough lesson I learned that evening, but I did learn something. I learned that if you stick your head in a fire it will burn your head and hurt. More importantly though, that lesson came from something beautiful.

That early life experience was something I wouldn't soon forget. Not only because I burned most of my head and upper torso, but because the combination of education and aesthetics was something I would not come across again for sometime. Throughout the rest of my life, excluding a very attractive 8th grade math teacher, the instruments of learning I encountered were not pretty. Physics textbooks, ingredient and nutrition charts, driver's ed videos, mattress tags, menu boards, owner's manuals, were all very unappealing. It was all just information thrown together without any semblance of design or style; form being a slave to function. People were treating information like medicine. It helps you and you need it, so it's okay if it tastes bad. It was as if I couldn't escape it. Everywhere I went — freeways, elevators, the Department of Motor Vehicles — information would rear its ugly head. All the while, I would think to myself, why does it have to be this way? Can't someone do something about it?

I had the answer all along, and I didn't even know it. It wasn't until one night when I was cooking dinner for a friend, that I finally saw the light. We were talking about this very subject when I leaned over the stove to season some vegetables, as I shifted my weight forward I slipped. I landed on top of the stove and my head briefly touched an oven coil, singeing one of my eyebrows.

Right at the moment I slipped, my friend said to me, "I don't get it Matt, can't something learn you and look nice too?" The timing of his question and the burning of my eyebrow were serendipitous. The lesson taught to me by the beautiful flames of a campfire came rushing back.

I turned to him and said, "Yes, yes it can. And it's teach not learn."

The answer; something that was informative yet aesthetically pleasing, buried for over twenty years, was unearthed by a hot oven coil and coincidence.

And Instructoart was born.

Matthew Vescovo – Master of the Obvious

THE AIRKISS

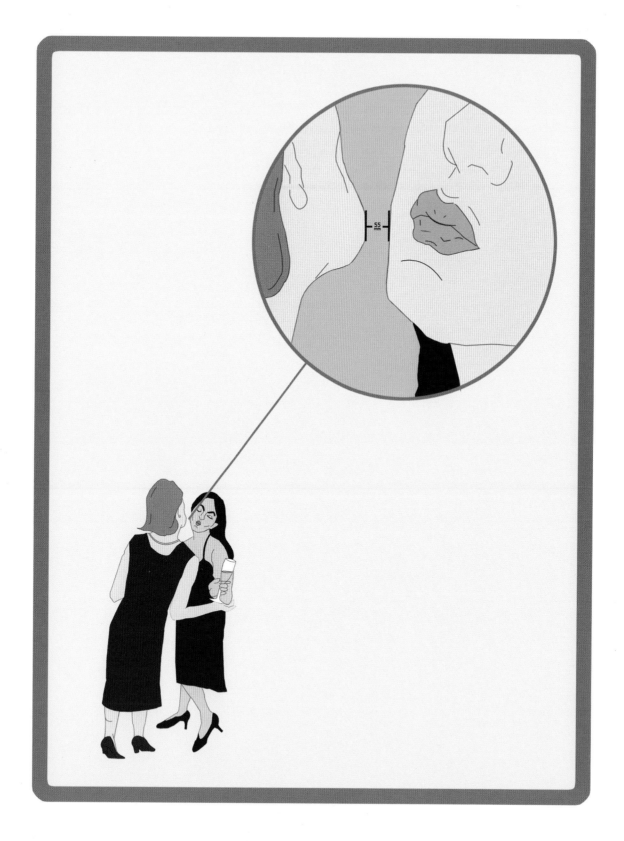

G-STRING GRATUITY

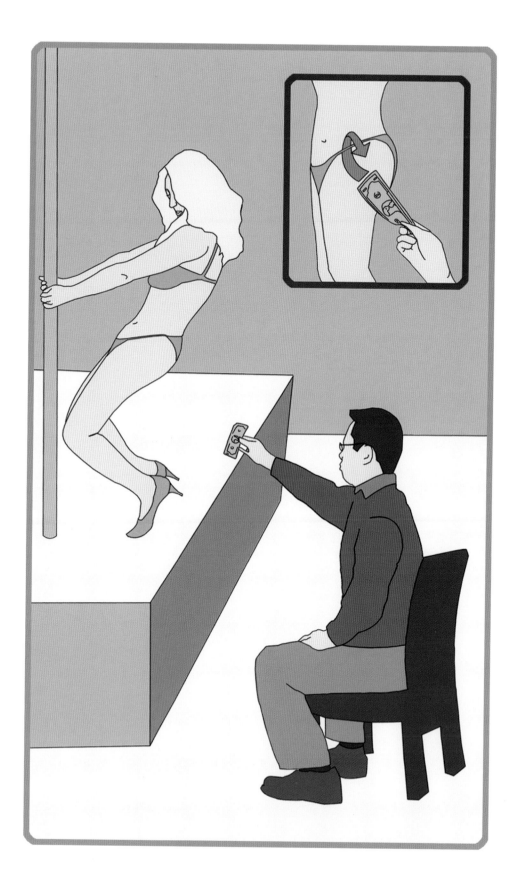

THAT'S WHAT IT'S ALL ABOUT

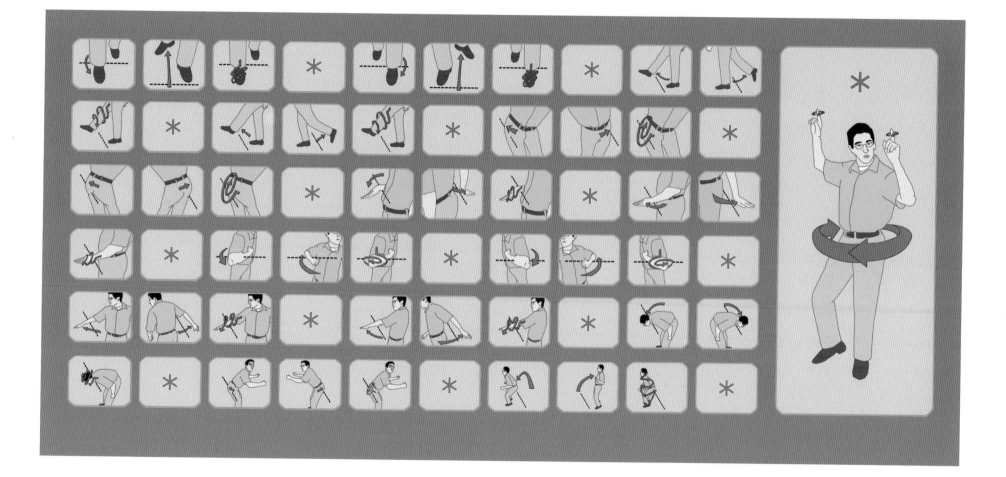

THE CANINE CODE

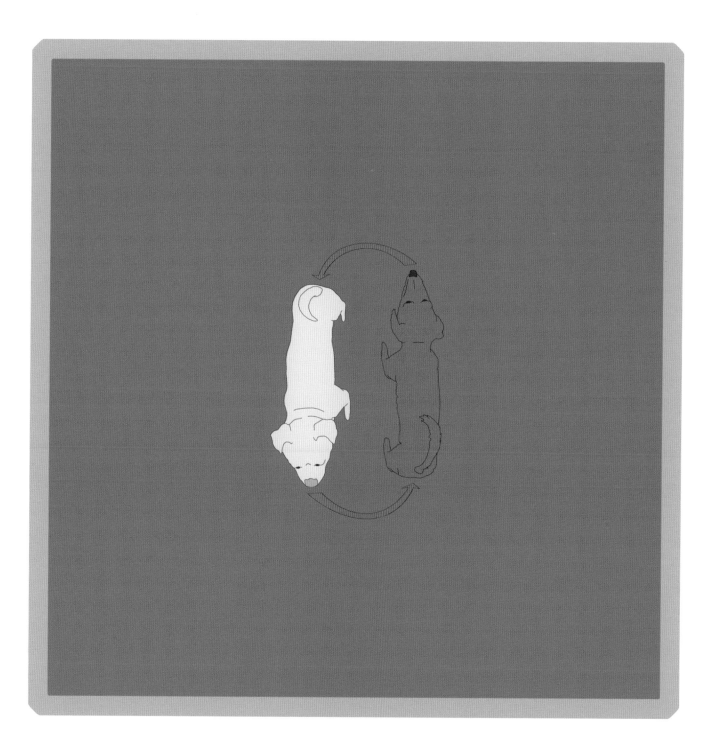

THE ELEVATOR FAKE OUT

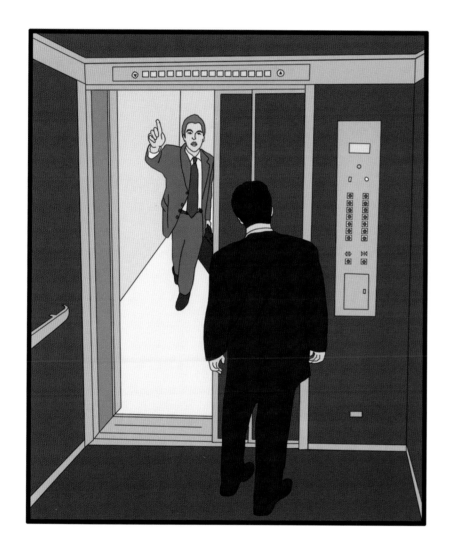

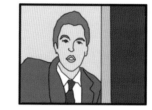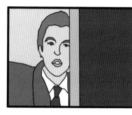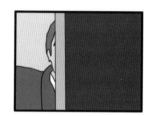

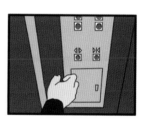

CHECK PLEASE

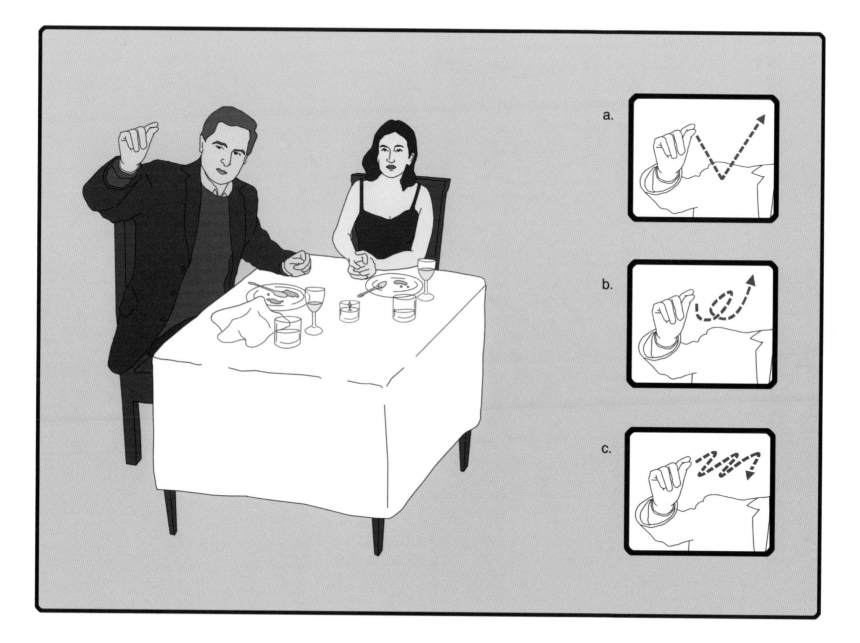

THE PEE PEE DANCE

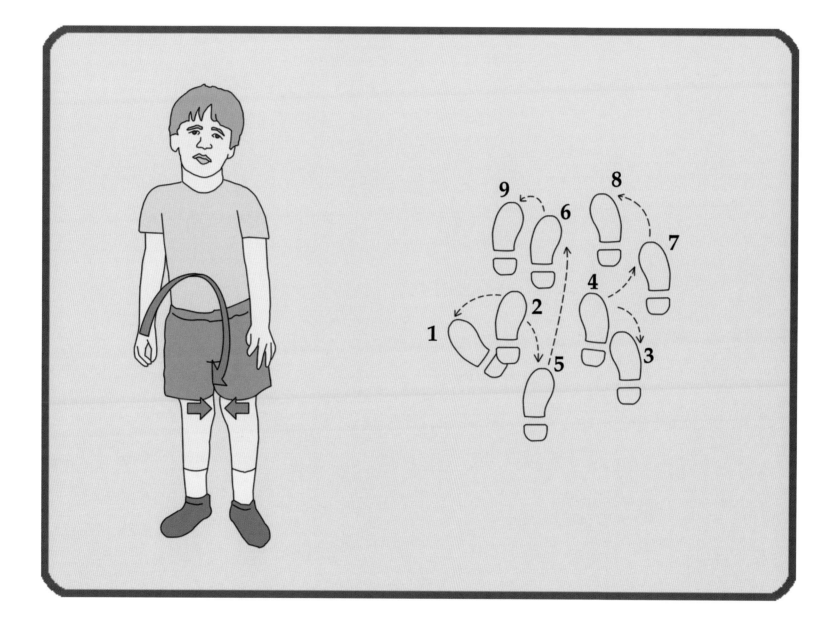

CATS AREN'T DOGS

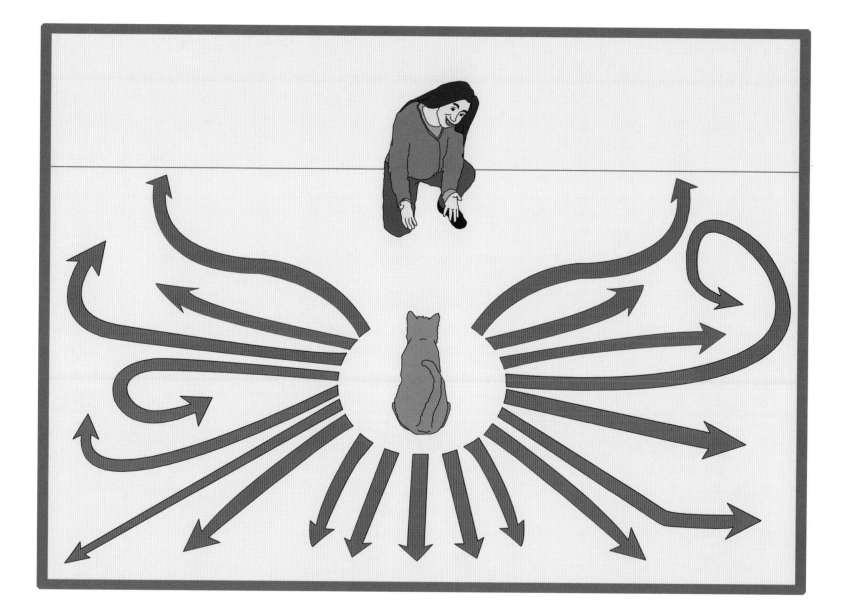

EMOTIONS: A HOW TO GUIDE

☐ ☐ ☐ ANGRY CONFIDENT CONFUSED
☐ ☐ ☐ PENSIVE NERVOUS HAPPY
☐ ☐ ☐ SHOCKED SAD SCARED

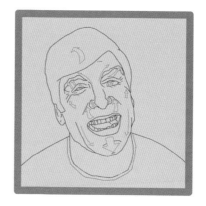
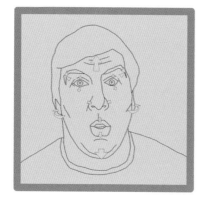
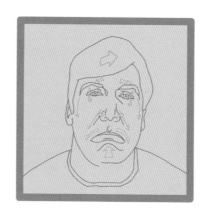
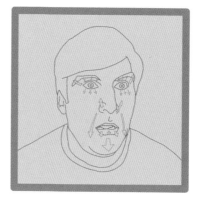

AS EASY AS 1...2...3

HOLLYWOOD ENDING

BLACK & CURLY

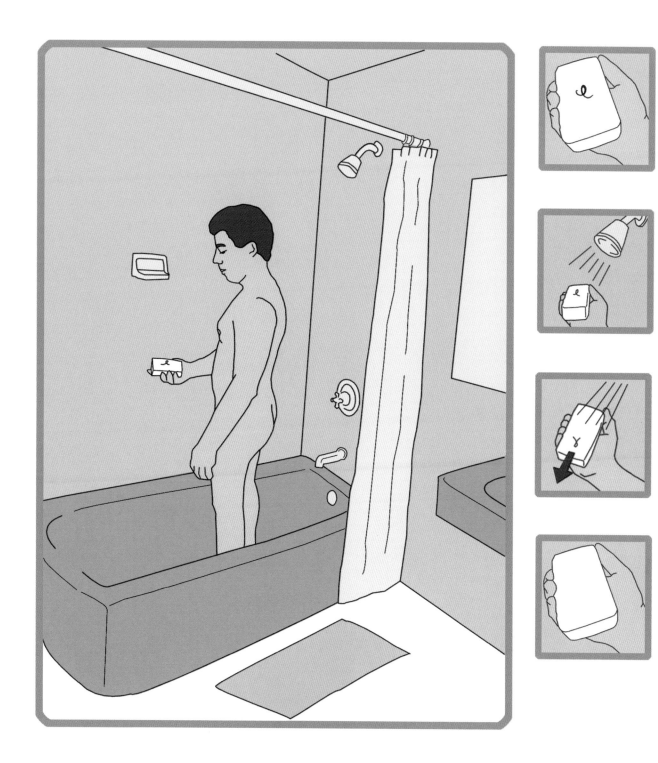

A BEGGAR'S PERSPECTIVE: THE EYES HAVE IT

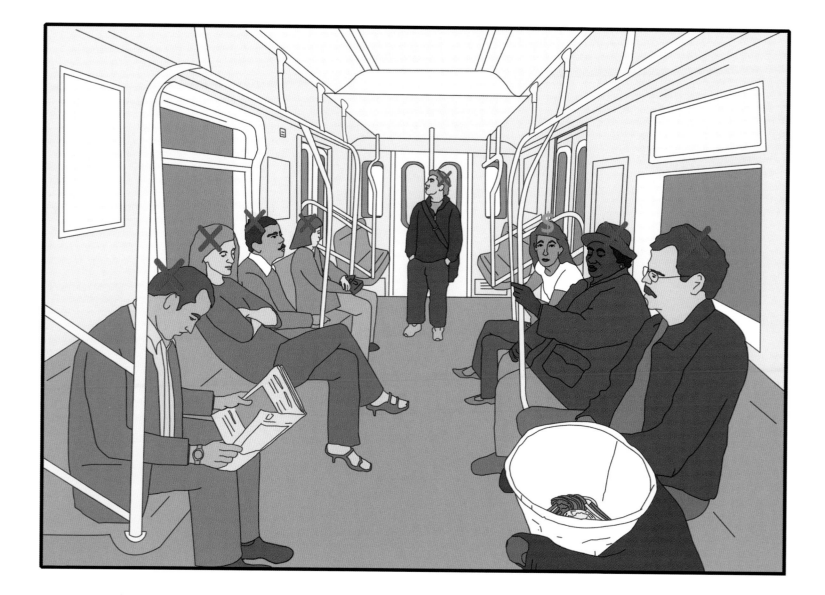

ALL PURPOSE MATERNAL SALIVA

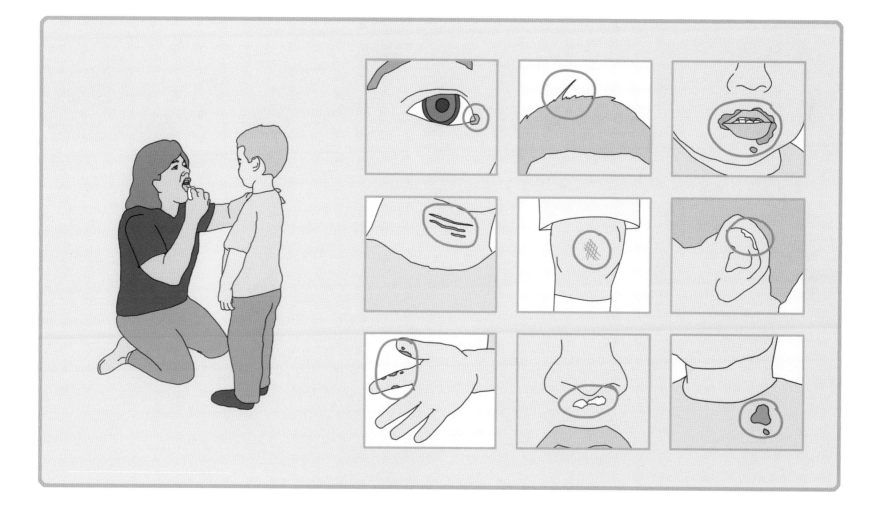

IN A MAN'S WORLD, EVERYTHING IS SEEN AS A COMPETITION

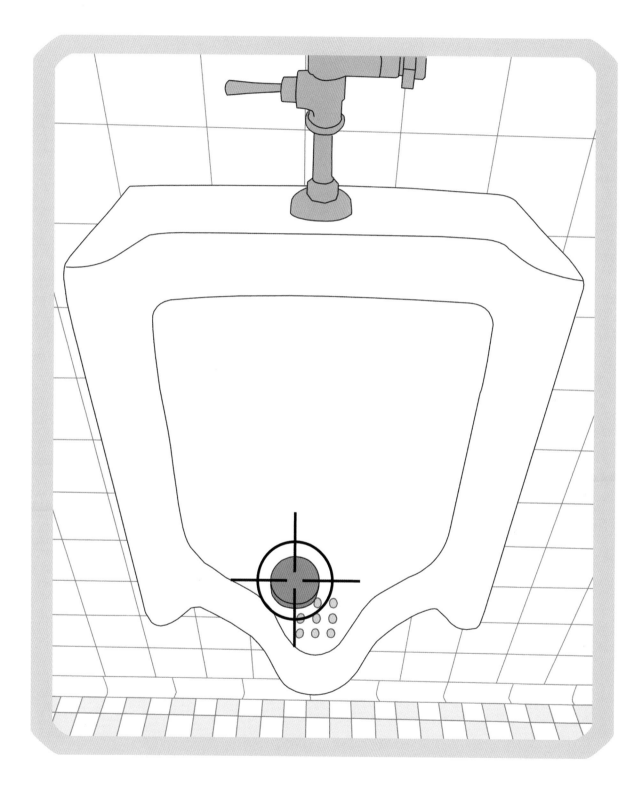

KARMA

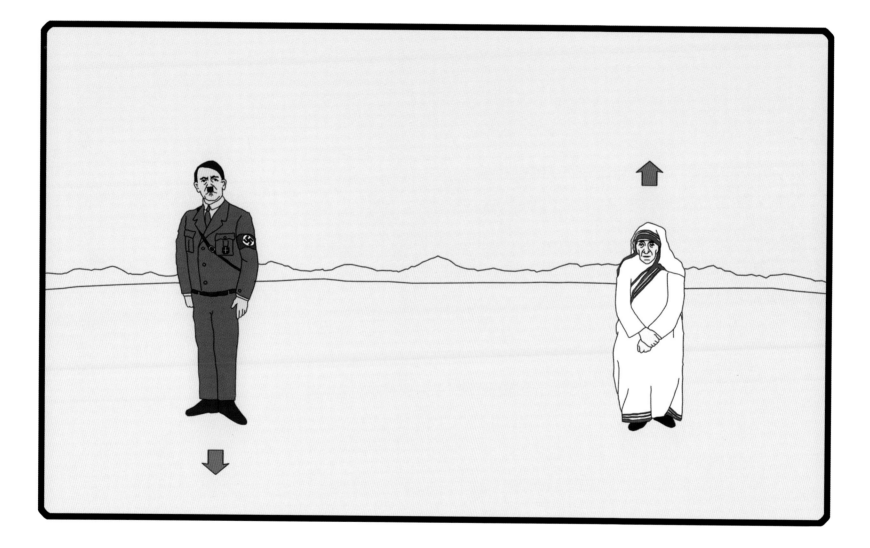

MIGHTY SCARED WHITIE

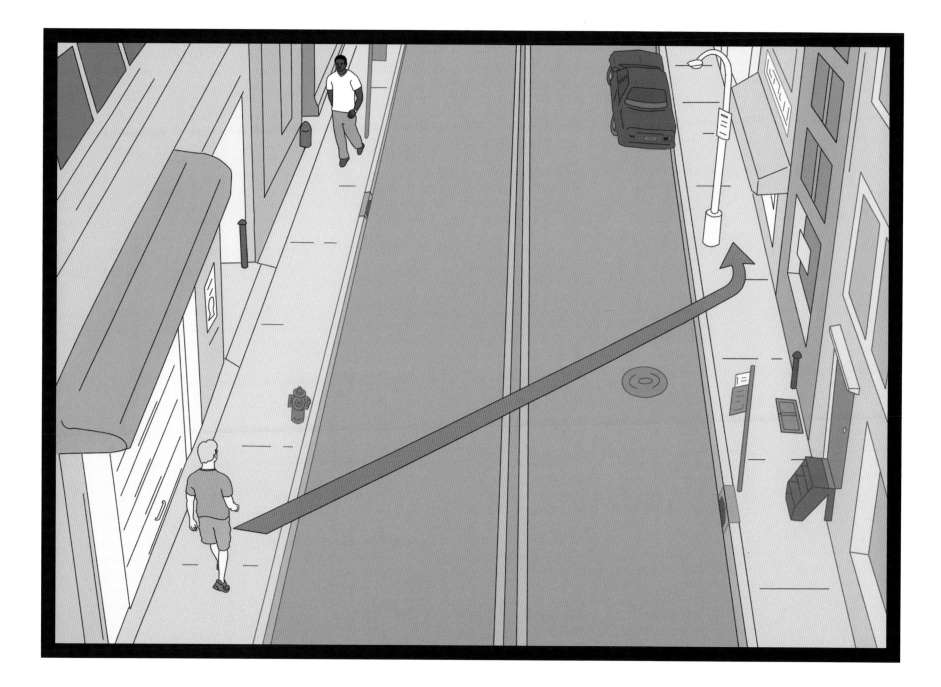

PROCLAMATION OF ONE'S OWN ATTRACTIVENESS

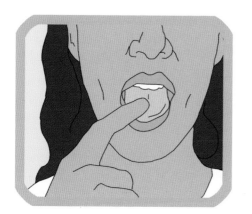 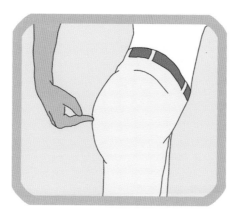

THE RATINGS SYSTEM

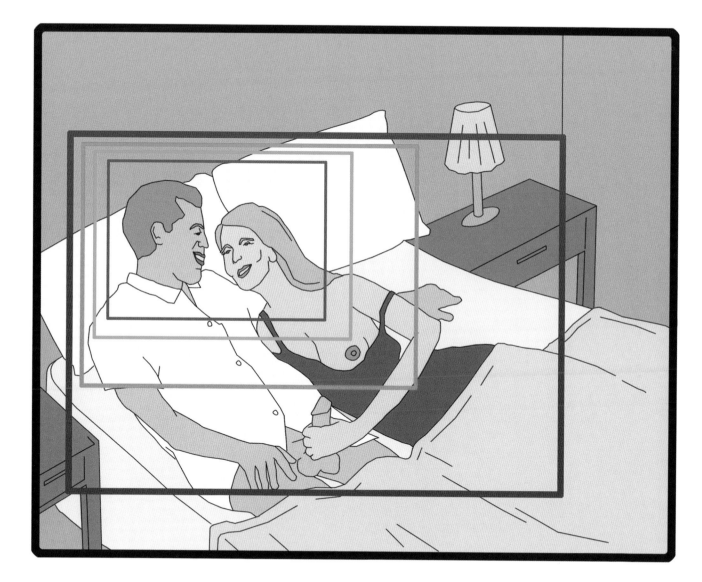

KNOW AND OBEY THE RULES OF THE SUPERMARKET

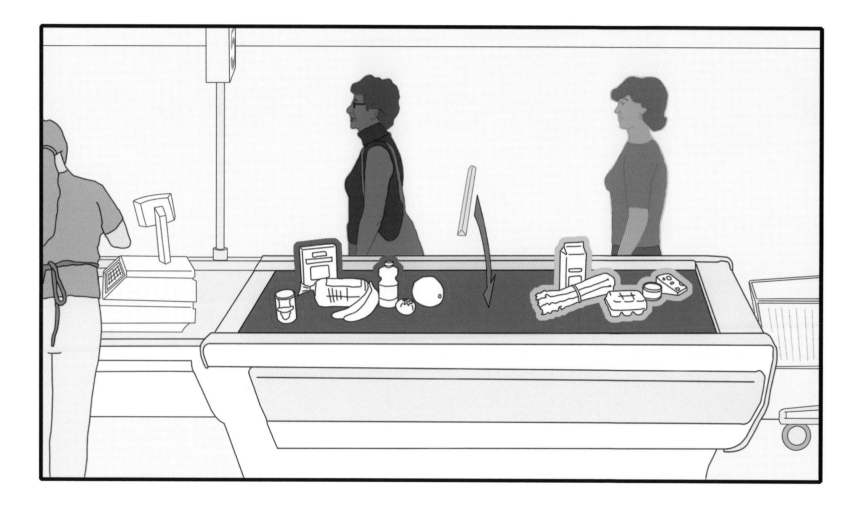

FART

PEOPLE YOU TRUST WITH YOUR CHILDREN (THE REVISED LIST)

BLANK THIS

CUCKOO

GAY. STRAIGHT.

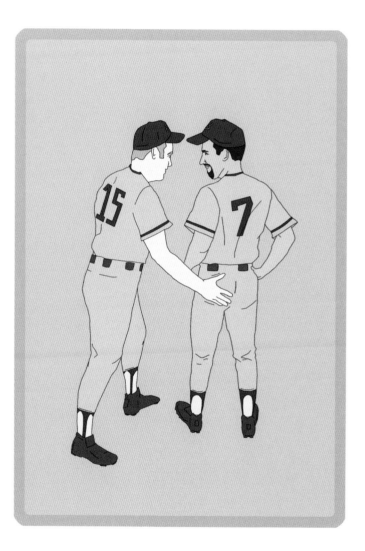

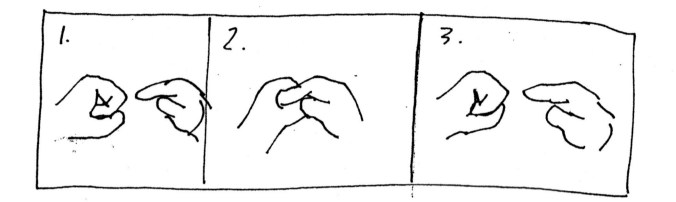

THIS WAS THE VERY FIRST INSTRUCTOART PIECE I DID. THEN CAME G STRING GRAVITY, BLACK AND CURLY, AND BLANK THIS. I REMEMBER THINKING THAT THE CONTENT WAS ALL A LITTLE LOW BROW AND MAYBE I SHOULD START AIMING A LITTLE HIGHER. BUT THEN I THOUGHT NO.

HAND MODEL: MATT VESCOVO

- AIR KISS

NOTHING SAYS,
"YOU'RE BENEATH ME",
BETTER THAN THE AIR KISS.
THIS GREETING IS VERY
POPULAR AMONG THE RICH.
FOR REASONS WHY THE
RICH HAVE ADOPTED THE
AIR KISS AS THEIR OWN,
SEE THE "THEY THINK THEIR
SHIT DOESN'T STINK" SECTION
OF THE CAT'S AREN'T DOGS
SKETCH NOTES.

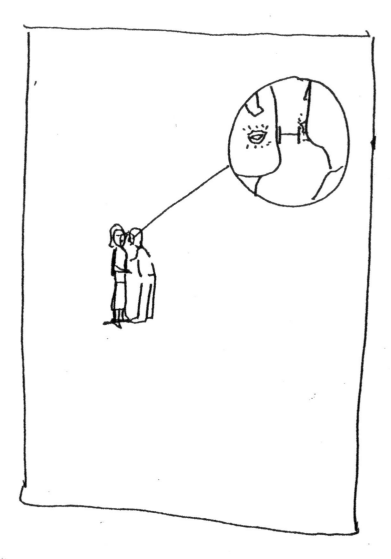

4/29/01

— NEW INSTRUCTOART.

BLACK AND
CURLY

⚡ THIS SITUATION IS FILLED
WITH IRONY. SOAP, AN
ITEM SYNONYMOUS WITH
CLEANLINESS IS SO EASILY AND
COMPLETELY SOILED, BY ONE
CURLY HAIR. THIS HAIR,
WHICH FELL OFF IT'S OWNER
WITH SUCH EASE, HOLDS ON
WITH A VICE LIKE GRIP ONLY RIVALED
BY A GIANT SQUID OF THE SEA.

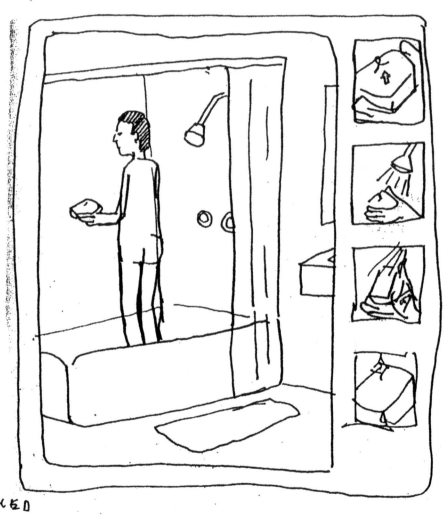

MODEL: MATTHEW VESCOVO

THE KEY FOR SUCCESSFUL REMOVAL, I FIND IS <u>PATIENCE</u>.

TAKE YOUR TIME. SEARCH. SEARCH FOR THE ~~RANGE~~ <u>EXACT</u> ANGLE.

<u>EVERY HAIR AND JET SPRAY HAS A DIFFERENT ANGLE.</u>

WORK IT BACK AND FORTH NICE AND SLOW.

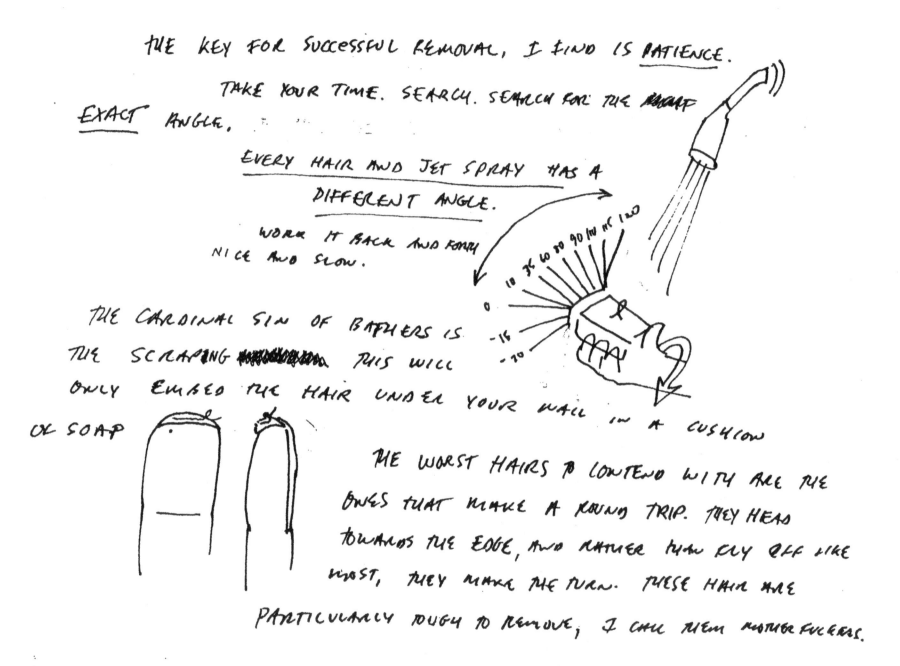

THE CARDINAL SIN OF BATHERS IS THE SCRAPING ~~XXXXXXXXXX~~ THIS WILL ONLY EMBED THE HAIR UNDER YOUR NAIL IN A CUSHION OF SOAP

THE WORST HAIRS TO CONTEND WITH ARE THE ONES THAT MAKE A ROUND TRIP. THEY HEAD TOWARDS THE EDGE, AND RATHER THAN FLY OFF LIKE MOST, THEY MAKE THE TURN. THESE HAIR ARE PARTICULARLY TOUGH TO REMOVE; I CALL THEM MOTHER FUCKERS.

◁ THE HOKEY POKEY SHOULD BE THE GREATEST GROUP DANCE OF ALL TIME.

THE ONLY PROBLEM IS THAT DJs AND BAND LEADERS WILL DO WHAT I CALL # "HOKEY AUDIBLES", WHERE THEY CHANGE THE ORDER OF THE DANCE OR LEAVE OUT BODY PARTS ENTIRELY. THEY MIGHT TRY AND MAKE THIS OUT TO BE A CASE OF CREATIVE LICENSE, BUT THE ONLY THING THEY CREATE IS UNCERTAINTY ON THE DANCE FLOOR.

I REMEMBER ONCE I WAS DOING THE HOKEY POKEY AT A BAR MITZVAH, AT ONE POINT I LOOKED AROUND THE CIRCLE OF PARTICIPANTS DANCING ALONG WITH ONE. WHAT DID I SEE?

NOT HAPPY FACES CELEBRATING A YOUNG JEWISH BOY'S TRANSITION INTO MANHOOD, BUT FACES KILLED WITH ANXIETY. THEY LOOKED NERVOUS AND

- 1 RIGHT FOOT x3
- 2 LEFT FOOT x3
- ~~3 RIGHT ARM x3~~
- ~~4 LEFT ARM x3~~
- 5 RIGHT LEG x 3
- 6 LEFT LEG x 3
- 7 RIGHT HAND x3
- 8 LEFT HAND x3 .
- 9 RIGHT ELBOW x3 ✓
- 10 LEFT ELBOW x3 ✓
- 11 RIGHT ARM x3 ✓
- 12 LEFT ARM x3 ✓

- 13 RIGHT ~~SHOULDER~~ HIP x3 ✓
- 14 LEFT ~~SHOULDER~~ HIP x3 ✓
- 15 BUTT x 3 ✓
- 16 HEAD x3 ✓
- 17 WHOLE SELF x3

UNSURE; BECAUSE THEY DIDN'T KNOW WHETHER. THEY WERE GOING TO HAVE TO PUT THEIR WHOLE SELF IN OR JUST THEIR HEAD.

THERE NEEDS TO BE A HOKEY POKEY STANDARD.

8/25/02.

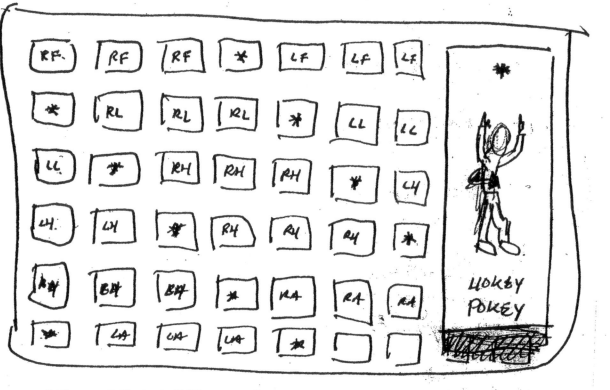

THROUGH INTENSIVE RESEARCH, I HAVE FOUND THE MOST COMMON/UNIVERSAL VERSION OF THE DANCE.

*LET THIS PIECE SERVE AS THE STANDARD.

MODEL: MY GOOD FRIEND IAN REICHENTHAL. BOWLING NICKNAME: MIGHTY MINK.

11/22/02

— GAY VERSES STRAIGHT

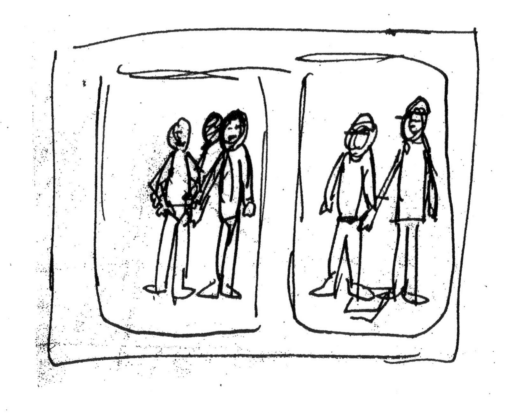

NEW TITLE: GAY. STRAIGHT.

IS IT POSSIBLE TO BE __TOO__ GAY? YES,

IT MOST CERTAINLY IS.

ORIGINALLY, WHEN I CAME UP WITH THIS CONCEPT, THE TWO GENTLEMEN IN THE FIRST PANEL WERE IN BATHING SUITS.

& EVEN WENT AS FAR TO SHOOT THE MODELS THIS WAY. I QUICKLY REALIZED THAT THIS MADE THEM TOO GAY. I MEAN THESE MEN WERE __SUPER GAY__.

SO I TURNED DOWN THE GAYNESS BY PUTTING CLOTHING ON THEM. TIGHT FITTING, VERY STYLISH CLOTHING MIND YOU.

[MODELS: (SLAPPER) PETER LORD (FRIEND) (SLAPEE) JOHN OGRODNICK (COUSIN)]

— 11/30/02

TITLE: ~~BOOBIED SOMETHING~~
MIGHTY SCARED WHITIE.

I HAD ASKED A BLACK FRIEND TO POSE FOR THIS PIECE, BUT DUE TO THE SUBJECT MATTER, I WANTED TO MAKE SURE HE WAS COOL WITH THE CONCEPT BEFORE WE MOVED FORWARD. WHEN I EXPLAINED THE IDEA AND FAXED HIM THE SKETCH, HE LIKED IT. HE FELT AS I DID, THAT IF ANYTHING IT MADE WHITE PEOPLE LOOK SILLY. WHEN HE ASKED ME ABOUT THE TITLE, I TOLD HIM IT WAS CALLED BLACK AND WHITE. TO ME THAT TITLE SEEMED TO WORK, IT REFERRED TO THE TWO PEOPLE IN THE PIECE, AND TO A LESSER DEGREE, REFERENCED THE PLAIN WAY I ILLUSTRATED AN UNSPOKEN WHITE URBAN TACTIC FOR ALL TO SEE. BUT WHEN I TOLD HIM THE TITLE, HE TOLD ME THAT THEN THE PIECE SEEMED TO BE INSTRUCTING WHITE PEOPLE TO CROSS THE STREET, WHEN THEY SAW A BLACK PERSON HEADED THEIR WAY. THIS WAS NOT THE EFFECT I HAD IN MIND.

SO I WENT BACK AND CHANGED THE TITLE, TO SOMETHING THAT MORE MOCKED THE WHITE PERSON'S ACTIONS. IN THE END, I THINK THIS TITLE IS A LOT FUNNIER AND MORE ACCURATE TO THE IDEA.

IT'S INTERESTING, I WAS TRYING TO CREATE SOMETHING THAT LOOKED AT A SITUATION FROM A BLACK PERSON'S PERSPECTIVE, BUT WHEN IT CAME TO THE TITLE, I WAS A HONKY ALL THE WAY

I THANK MY FRIEND FOR THE CORRECTION. HE NEVER WOUND UP POSING FOR ME, BUT HIS HELP WITH THE TITLE MADE THE PIECE WHAT IT IS.

HONKY

MODELS: PATRICK SHANDRICK (FRIEND) MARCEL JENNINGS (FRIEND) COPY EDITOR: JUNIOR MCRAE

1/21/03

TITLE: CAT'S AREN'T DOGS

◁ IT'S AMAZING TO ME, THAT A CREATURE THAT DOES ITS BUSINESS IN A BOX, FOR EVERYONE TO SEE AND SMELL CAN ACT THEIR SHIT DOESN'T STINK.

CAT'S ARE LIKE THE FRENCH OF THE ANIMAL WORLD.

EVEN CAT OWNERS WILL SAY, "MY CAT IS SO GOOD, HE'S LIKE A DOG." I JUST WONDER HOW CATS GOT THIS ATTITUDE, THAT THEY'RE BETTER THAN OTHER PETS.

IS IT BECAUSE THEY ARE PART OF THE CAT FAMILY AND LIONS ARE KINGS OF THE JUNGLE? LIKE THERE IS SOME SORT OF TRICKLE DOWN EFFECT. WELL, HERE'S A NEWS FLASH KITTIES; LIONS ARE KINGS OF THE JUNGLE BECAUSE THEY CAN KILL EVERYONE ELSE. THIS DOES NOT APPLY TO YOU.

MODELS: MAX (MY CAT) JUSTINE HENNING (MY NEIGHBOR)

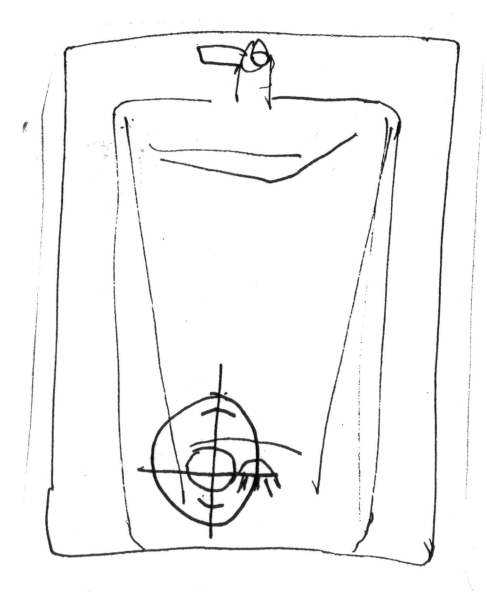

IN A MAN'S WORLD
EVERYTHING IS A COMPETITION.

- 2/25/03

◁ I WAS AT A
URINAL IN A
BATHROOM IN
BOSTON. AS I
BEGAN TO URINATE,
I FOUND MYSELF
AIMING MY

STREAM AT THE
URINAL CAKE.

I DID THIS ALMOST SUBCONSCIOUSLY, AS IF MY HAND AND PENIS HAD AGREED TO THIS GAME WITHOUT LETTING ME KNOW IT. ALL I KNOW IS THAT I NAILED THAT URINAL CAKE RIGHT IN THE CENTER WITH MY PEE FOR 8 OR 9 SECONDS. DAMN I'M GOOD. BUT WHY? WHY DID I DO THIS?

WHO AM I IMPRESSING WITH THIS AMAZING DISPLAY?

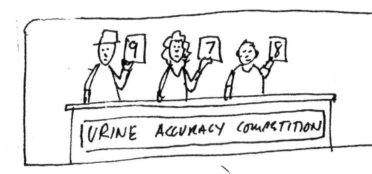

URINE ACCURACY COMPETITION

THE MORE I THOUGHT ABOUT IT, I REALIZED THAT GUYS CONSTANTLY NEED POSITIVE AFFIRMATION. SO THEY SET UP THESE LITTLE EVENTS DURING THE DAY THAT THEY CHALLENGE THEMSELVES WITH.

"I CAN HIT A PINK DISC, THAT IS 4 TO 5 INCHES AWAY FROM ME WITH MY URINE. I LIKE ME."

IT SEEMS LIKE A GUY THING, I WOULDN'T THINK WOMEN GO THROUGH THE SAME EXERCISES. * NOT BECAUSE I DON'T THINK THEY CAN AIM THEIR URINE, OR AT LEAST THE ONES I MET CAN'T, BUT BECAUSE THEY DON'T SEEM TO NEED TO.

* IF YOU ARE A WOMAN WHO CAN AIM HER URINE, PLEASE EMAIL ME AT MATT @ INSTRUCTOART.COM

SUPERMARKET RULES. KNOW THEM.

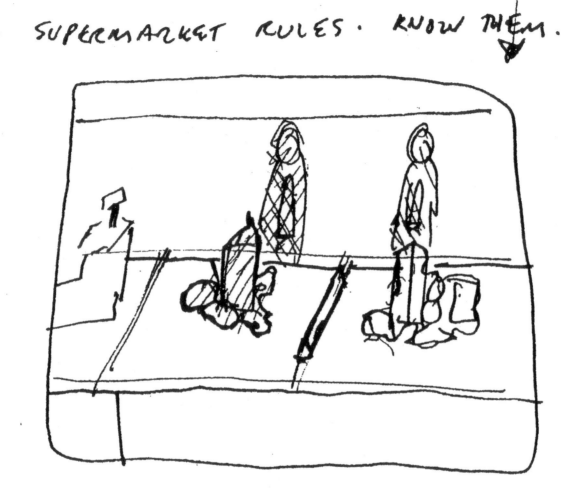

—4/14/03 KNOW AND OBEY THE RULES OF THE SUPERMARKET.

{ AT THE CHECKOUT LINE, THERE IS A LEVEL OF PARANOIA AND

ANXIETY THAT IS UNRIVALED. WHEN THAT

LITTLE BAR IS NOT AROUND.

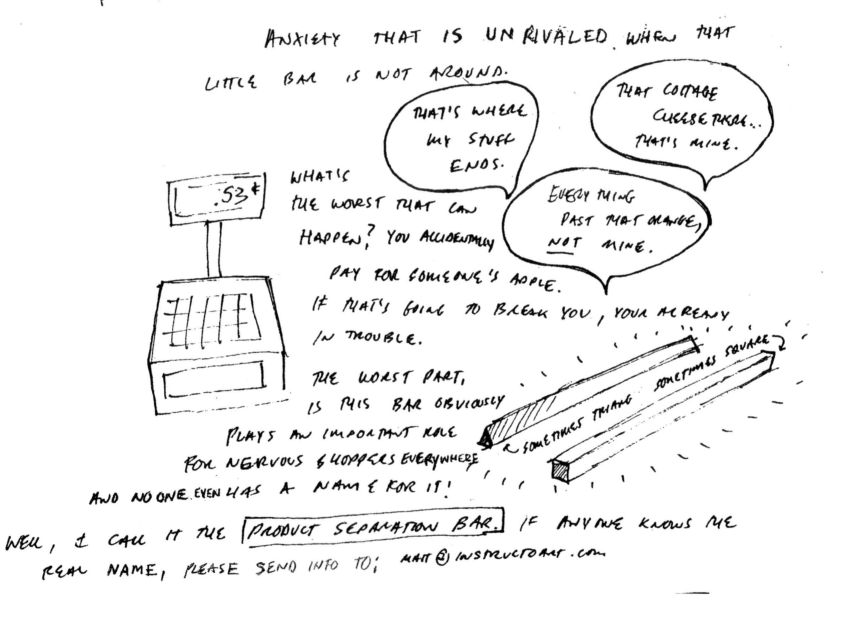

THAT'S WHERE MY STUFF ENDS.

THAT COTTAGE CHEESE THERE... THAT'S MINE.

EVERY THING PAST THAT ORANGE, NOT MINE.

WHAT'S THE WORST THAT CAN HAPPEN? YOU ACCIDENTALLY PAY FOR SOMEONE'S APPLE. IF THAT'S GOING TO BREAK YOU, YOUR ALREADY IN TROUBLE.

THE WORST PART, IS THIS BAR OBVIOUSLY PLAYS AN IMPORTANT ROLE FOR NERVOUS SHOPPERS EVERYWHERE AND NO ONE EVEN HAS A NAME FOR IT!

& SOMETIMES TRIANG SOMETIMES SQUARE

WELL, I CALL IT THE | PRODUCT SEPARATION BAR. | IF ANYONE KNOWS ME REAL NAME, PLEASE SEND INFO TO: MATT @ INSTRUCTOART.COM

(WIFE'S BEST FRIEND)

[MODELS: DOLLY STERNESKY (MOTHER-IN-LAW) NICOLE GUILIANI CLEMENTE

4/28/03

MATERNAL ~~MOMMY~~ SALIVA: THE ALL PURPOSE CLEANSER.

{ IT CLEANS,

DISINFECTS,

AND SMELLS

LIKE YO' MOMMA.

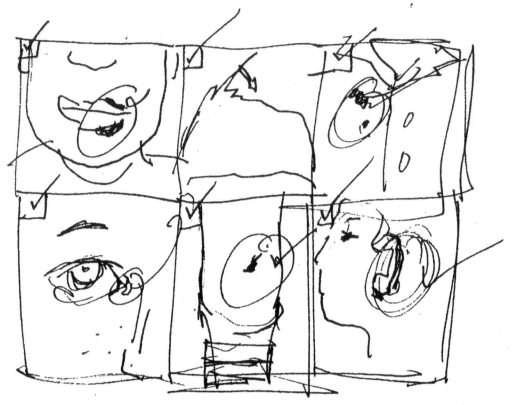

Γ IF SOMEONE

COULD FIGURE

OUT AN WAY TO BOTTLE THIS STUFF, I THINK IT WOULD SELL
LIKE CRAZY. I'M WORKING ON IT RIGHT NOW MYSELF. IF I COULD
JUST GET MY WIFE AND HER MOMMY GROUP FRIENDS TO PLAY BALL, I'M

| HERE ARE SOME INITIAL PRODUCT NAMES: | IN BUSINESS.

1. MOMTASTIC
2. MOMMY SPIT
3. LICKETTY SPIT
4. WILL YOU STAND STILL WHILE I WIPE YOUR FACE.
5. MATERNAL MAGIC

- PEOPLE YOU'D ~~LEAVE~~ TRUST

WITH YOUR CHILD ~~PARENTS~~

1. GRANDPARENTS
2. BABY SITTER / NANNY

3. TEACHER

4. DR.

{ THIS WAS THE ONLY PIECE I FELT UNCOMFORTABLE ABOUT DOING. MAYBE IT WAS MY FEAR OF GOD, MAYBE IT WAS MY ROMAN CATHOLIC GUILT KICKING IN, BUT I WAS RELUCTANT TO SEE IT THROUGH. IT WAS THE SECOND TO LAST PIECE I DID. I GUESS I WAS HOPING TO TOP IT, BUT IN THE END I FELT IT WAS WORTH DOING. AND I REALIZED IT ISN'T A SLAM ON GOD, AS MUCH AS THE MEN OF GOD. THE WHOLE IDEA OF NOT ALLOWING PRIEST TO MARRY OR HAVE SEX WAS NOT GOD'S IDEA, BUT MANS. GOD CREATED US TO BE SEXUAL BEINGS, ITS PART OF WHO WE ARE. YOU SUPRESS THOSE VERY NATURAL URGES LONG ENOUGH AND THEY WILL COME OUT ONE WAY OR THE OTHER. I ALSO THINK IT'S CRAZY NOT TO ALLOW WOMEN TO BECOME PRIESTS. OKAY THAT WAS THE SERIOUS PORTION OF THE BOOK. BACK TO FARTS, PUBIC HAIR, AND URINE.

MODELS: MICHAEL VESLOVO (DAD) CONNIE VESLOVO (MOM) NANCY VESLOVO (WIFE) ANTHONY CAMPAGIORNI (FRIEND) MATHEW VESLOVO, SUE HILDEBRAND (FRIEND) ANTHONY LITO (FRIEND) RAY STERNESKY (FATHER IN LAW) JOEL LEARY (FRIEND) CHRIS LEARY (FRIEND)

-6/6/03

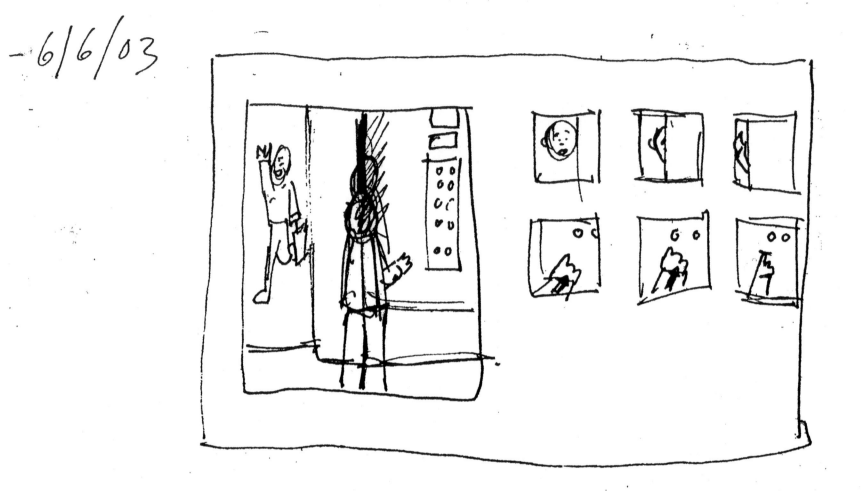

THE ELEVATOR FAKEOUT

↳ C'MON YOU KNOW YOU DO IT.

MODELS: (IN ELEVATOR) MATT VESCOVO (OUT OF ELEVATOR) MATT VESCOVO

BIOGRAPHY

Matt Vescovo went to Syracuse University where he studied advertising design. Upon graduating from college Matt started working in advertising as an art director. Even though he achieved success in the ad world, Matt never forgot his first love, chemistry. Unfortunately, Matt really wasn't smart enough to become a chemist. So he moved onto his second love, art. Matt found that he can express himself purely through his art, free from the crass commercialism of his chosen profession. It is this freedom which allowed him to create Instructoart — something he hopes will become so popular that it can be spun off into an animated sitcom, full length film, or extended into a line of children's toys and videos. Matt creates Instructoart in the home office he shares with his lovely wife Nancy, in Brooklyn, New York. They share that home with their beautiful daughter, Lola Ray.

Each Instructoart piece in this book is also part of a signed limited edition of five.
These pieces are printed large format on archival paper with pigment inks.
If you are interested in exhibiting or purchasing Instructoart, please visit our website for more details.

There's more learining to do.

INSTRUCTOART.COM

Matthew Vescovo: INSTRUCTOART | Master of the Obvious. Lesson 1

All images and text ©2003 Instructo, LLC

Published by
Instructoart Book Associates, a joint venture between Jorge Pinto Books and Instructo, LLC

Design and typesetting: Susan Hildebrand
Printed and bound in China by Toppan Printing Inc., Hong Kong, China
ISBN 0-9742615-0-5

Available through D.A.P./Distributed Art Publishers
155 Sixth Avenue, 2nd Floor, New York, NY 10013
Tel: (212) 627-1999 Fax: (212) 627-9484
Library of Congress Cataloging -in- Publication Data

Matthew Vescovo
Instructoart Lesson 1, a humorous, fun collection of informative art.

Instructoart Book Associates would like to thank its sponsors for their support.